MARTA POPOWSKA

ROLLER SKATERS

LIFE IS BETTER ON 8 WHEELS

T0402001

teNeues

Aylen Benitez. Location: MACBA Museum, Barcelona.

RT CONTEMPORANI D

A LOVE STORY ON 8 WHEELS

The very sight of roller skates brings back childhood memories, especially for those of us who grew up in the 70s and 80s. We zoomed across the asphalt, skinning our knees for the first time. And then there are the pictures of happy-go-lucky California girls skating around at Venice Beach – and many boys, too, for that matter.

Roller skates are more than a means of transport; they are a way of life. Music has always set the pace, and it's hard to imagine pop culture without these eight wheels. Cher ("Hell on Wheels"), Dire Straits ("Skateaway"), De La Soul ("A Roller Skating Jam Named "Saturdays"") and Beyoncé ("Blow") made roller skating a theme in their songs or music videos.

Movies from the 1970s like *Rollerball* and *Kansas City Bomber* offer action and speed instead of disco. In these movies, James Caan and Raquel Welch compete in fast-paced and – in *Rollerball* – even deadly races on skates. Roller derby, a popular sport since the 1930s, served as a theme for both films. For younger audiences, Drew Barrymore's 2009 coming-of-age story *Whip It* presented a more contemporary blueprint that helped modern-day roller derby clubs gain huge numbers, especially in English-speaking countries.

Roller Derby and Park Skating

The new version of the sport that emerged after the start of the millennium was initially only played by women. The feminist and grassroots approach promised empowerment and a feeling of community. While roller derby had been played exclusively on banked tracks in previous decades, the Texas Rollergirls' idea to move the sport to a flat track brought about an international breakthrough. Flat track roller derby was now possible in every fairly large sports facility. The U.S. was followed by England, Germany, France – within a few years, women all over the world were skating on ovals. What was originally mainly for fun developed into a professional sports competition with association and world championships.

Antique roller skates with iron wheels, likely made in the early 20th century.

Antike Rollschuhe mit Eisenrollen, Baujahr wahrscheinlich Anfang des 20. Jahrhunderts.

To astonished onlookers, the tricks performed by park and street skaters look every bit as daring as the maneuvers of the derby players. They glide through concrete pools up to 12 feet deep like surfers riding waves; they jump stairs and do daredevil flips in half-pipes. Fall down, get up, keep going: Along with the adrenaline rush, there are also lessons for life and for learning self-confidence. Until the 1990s, mainly male roller skaters were seen in the skate parks, then many of them switched to inline skating. Now it is mostly women on roller skates there, which may be due to the fact that many of the female athletes come from roller derby. This trend intensified during the pandemic: Caused by the suspension of practice during the lockdowns, the female players looked for alternatives.

The Invention of the Roller Skate and Roller Dance

Did Jean-Joseph Merlin and James L. Plimpton ever dream of all this for their inventions? In 1760, Merlin, who was Belgian, constructed the first shoe with three wheels mounted one behind the other – similar to to-day's inline skates. A hundred years later, Plimpton, an American, revolutionized the world of roller skates. In 1863, he conceived the idea of attaching axles and four wheels to each shoe. He opened the first roller skating

Chicago's renowned roller dancer Smooth Goddess at Skate Love Barcelona 2022.

Die bekannte Rollschuhtänzerin Smooth Goddess aus Chicago beim Skate Love Barcelona 2022.

Argentina's Agustina Montañés during a skate park competition at Skate Love Barcelona 2021.

Agustina Montañés aus Argentinien während eines Skate-Park-Wettbewerbs im Rahmen des Skate Love Barcelona 2021.

rinks in New York City and Newport, Rhode Island, complete with roller skate rentals. The idea caught on in Europe as well.

While roller skating in most countries took the form of mainly competition-based artistic skating in the 20th century, Black Americans in the U.S. developed their own skating culture that extended far beyond dancing. Rhythm skating, also frequently called roller dancing today, originated during the civil rights movement between the late 1950s and the late 1960s. Black Americans protested non-violently against the discriminatory racial segregation laws. Evenings at roller rinks were separated by skin color, and Blacks were only allowed to go to Rhythm Night, Soul Night, or Adult Night.

Creativity on Wheels

Rinks became places that gave people their identity. The days long before social media proved to be a blessing in disguise. There was no possibility for people to copy others; they had to resort to their own creativity. This was how different dance styles developed in the U.S. metropolises between the East and West Coasts, fueled by the beats of the rink DJs, the secret stars of the skating world. New York became popular for its roller discos. At the legendary Empire Skating Rink, Cher was seen skating alongside roller disco legend Bill Butler. In the early 1970s, skaters in Chicago created JB Style, named after the Godfather of Soul himself, James Brown. And in San Francisco, people met in Golden Gate Park to devise new steps.

To this day, the dance styles of the rinks offer a source of inspiration for skaters worldwide. Every September, the international community gathers in Spain. At the Skate Love Barcelona Festival, people roller dance under the bright sun, sharing their skills. There is talk of skaters who don't take their skates off for days at a time during the festival, in keeping with the motto *Life is better on 8 wheels.*

A LOVE STORY ON 8 WHEELS

Der Anblick von Rollschuhen weckt Kindheitserinnerungen, besonders bei jenen, die in den 70er und 80er Jahren aufgewachsen sind. Man sauste über den Asphalt und holte sich die ersten aufgeschlagenen Knie. Und dann sind da die Bilder der California Girls, die unbeschwert am Strand von Venice Beach ihre Runden drehen – wie viele Boys im Übrigen auch.

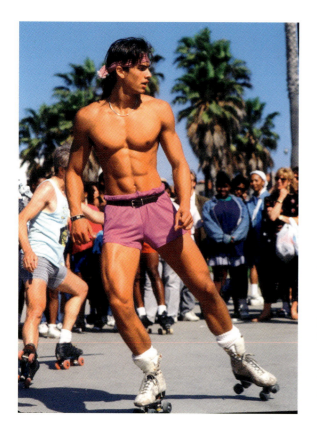

Roller Skates transportieren nicht nur Menschen, sondern auch ein Lebensgefühl. Musik gibt dabei seit jeher den Takt vor, aus der Popkultur sind die acht Rollen nicht wegzudenken. Cher (*Hell on Wheels*), Dire Straits (*Skateaway*), De La Soul (*A Roller Skating Jam Named „Saturdays"*) oder Beyoncé (*Blow*) haben Roller Skating zum Thema in ihren Songs oder Musikvideos gemacht. Action und Speed statt Disco bieten 70er-Jahre-Filme wie *Rollerball* und *Kansas City Bomber*. James Caan beziehungsweise Raquel Welch liefern sich darin rasante bis – im Fall von *Rollerball* – gar lebensgefährliche Rennen auf Skates. Die seit den 30er Jahren populäre Sportart Roller Derby diente in beiden Filmen als Vorlage. Dem jüngeren Publikum lieferte Drew Barrymore 2009 mit ihrer Coming-of-Age-Story *Roller Girl* (Orig. *Whip It*) eine zeitgemäße Blaupause, die den modernen Roller-Derby-Clubs vor allem im englischsprachigen Raum einen enormen Zulauf verschaffte.

Roller Derby und Park Skating

Die nach der Jahrtausendwende neu entstandene Variante des Sports wurde zunächst nur von Frauen gespielt.

Marcus Schenkenberg, roller skating at Venice Beach, California, where he was discovered in 1989. He is considered the first male supermodel.

Marcus Schenkenberg skatet in Venice Beach, Kalifornien, wo er 1989 entdeckt wurde. Er gilt als das erste männliche Supermodel.

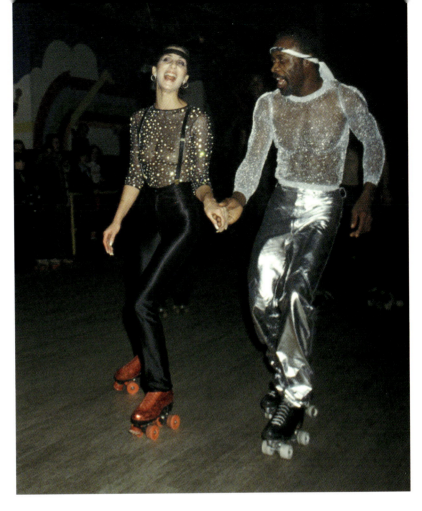

Cher skates with roller disco celebrity Bill Butler at the legendary
Empire Roller Disco Skating Rink in New York City in 1979.

Cher und die Roller-Disco-Legende Bill Butler im berühmten Empire
Roller Disco Skating Rink in New York City im Jahr 1979.

Der feministische und basisdemokratische Ansatz versprach Empowerment und Gemeinschaftsgefühl. War das Roller Derby der vergangenen Jahrzehnte ausschließlich auf geneigten Bahnen gespielt worden, brachte die Idee der Texas Rollergirls, den Sport auf eine flache Bahn zu verlegen, den internationalen Durchbruch. Flat Track Roller Derby war nun in jeder größeren Sporthalle möglich. Auf die USA folgten England, Deutschland, Frankreich – binnen weniger Jahre rollten Frauen auf der ganzen Welt im Oval. Was anfangs vor allem Spaß war, entwickelte sich zu einem leistungssportlichen Wettkampf mit Verbands- und Weltmeisterschaft.

Ebenso kühn wie die Spielmanöver der Derby Player wirken die Tricks von Park und Street Skatern auf staunende Zuschauer. Sie gleiten durch meterhohe Beton-pools wie Surfer über Wellen, springen Treppen hinunter oder machen waghalsige Flips in Halfpipes. Hinfallen, aufstehen, weitermachen: Neben dem Adrenalinstoß gibt es Lektionen fürs Leben und Selbstbewusstsein. Bis in die 90er Jahre sah man vor allem männliche Skater in den Skateparks, dann tauschten viele von ihnen die Rollschuhe gegen Inline-Skates. Nun sind dort vor allem Frauen auf Rollschuhen unterwegs, was daran liegen mag, dass viele der Sportlerinnen vom Roller Derby kommen. Dieser Trend hat sich

während der Pandemie noch verstärkt: Bedingt durch den eingestellten Trainingsbetrieb in den Lockdowns suchten die Spielerinnen nach Alternativen.

Die Erfindung des Rollschuhs und Roller Dance

Ob Jean-Joseph Merlin und James L. Plimpton sich all das für ihre Erfindungen erträumten? Der Belgier Merlin konstruierte 1760 den ersten Schuh mit drei hintereinander angeordneten Rollen – ähnlich dem heutigen Inline-Skate. Hundert Jahre später revolutionierte der US-Amerikaner Plimpton die Rollschuhwelt. Er kam 1863 auf die Idee, Achsen und vier Rollen je Schuh anzubringen. Er eröffnete die ersten Roller-Skating-Rinks, wie Rollschuhbahnen genannt werden, in New York City und Newport (Rhode Island), samt Rollschuhverleih. Die Idee fand auch in Europa Anklang.

Während das Rollschuhlaufen im 20. Jahrhundert in den meisten Ländern überwiegend in Form von wettbewerbsorientiertem Kunstlauf ausgeübt wurde, entwickelten Afro-Amerikaner in den USA eine eigene Skatekultur, die weit über das Tanzen hinausreicht. Rhythm Skating, heute häufig auch Roller Dancing genannt, hat seinen Ursprung in der Zeit der Bürgerrechtsbewegung zwischen den späten 50er und dem Ende der 60er Jahre. Afroamerikaner protestierten gewaltfrei gegen die diskriminierenden Gesetze der Rassentrennung. Abende in den Roller Rinks waren nach Hautfarben getrennt. Schwarze durften nur zur „Rhythm Night", „Soul Night" oder „Adult Night".

Kreativität auf Rollen

Rinks wurden zu identitätsstiftenden Orten. Die Zeiten lange vor Social Media entpuppten sich dabei als Segen. Abschauen ging nicht, man musste auf seine eigene Kreativität zurückgreifen. So entwickelten sich in den US-Metropolen zwischen Ost- und Westküste unterschiedliche Tanzstile, angeheizt von den Beats der Rink-DJs, den heimlichen Stars der Szene. New York wurde für seine Roller Discos populär. Im legendären Empire Skating Rink tanzte Cher an der Seite von Roller Disco Legende Bill Butler. Anfang der 70er Jahre kreierten Skater in Chicago den JB Style, benannt nach dem Godfather des Soul James Brown. Und in San Francisco traf man sich im Golden Gate Park, um neue Schritte zu entwickeln.

Bis heute sind die Tanzstile der Rinks Inspirationsquelle für Skater weltweit. Jeden September versammelt sich die internationale Szene in Spanien. Beim Skate Love Barcelona Festival tanzt man unter der Sonne und tauscht sein Können aus. Man hört von Skatern, die dort tagelang ihre Rollschuhe nicht ausziehen, ganz nach dem Motto *Life is better on 8 Wheels*.

A feeling of community and team bonding are the key creeds in roller derby.

Gemeinschaftssinn und Zusammenhalt im Team sind zentrale Kredos beim Roller Derby.

Skate instructor CeCe Skatefantacee from Atlanta, Georgia, with other dancers on the dance floor. Skate Love Barcelona 2022.

Skate Instructor CeCe Skatefantacee aus Atlanta, Georgia, gemeinsam mit anderen Tänzerinnen auf dem Dancefloor. Skate Love Barcelona 2022.

ROLLER

DANCE

DANCE

Ballet and modern dance have long been Keon Saghari's focus in life. The California-born dancer with Iranian roots began her training at the age of three. For years, she danced on American and international stages – right up to the point where the physical demands and mental strife paired with being a dancer outweighed the joy she found in it. "My priorities were shifting and my relationship to dance was beginning to feel less fulfilling than it used to."

As Keon put a pause on dance, life without physical activity was unimaginable for her, so she grabbed a pair of roller skates. "I started skating so I could still move my body and enjoy music in a similar way to dance, but without the same pressure and emotional baggage." Skating is a full-body experience for her and her movement is shaped by her history as a dancer. She doesn't just focus on the steps, she also involves her upper body and arms. Ballet, modern, jazz, and contemporary dance: Her style is a fusion of everything, with major influence from JB and jam skating. "I don't just follow one specific skating style, I allow the music to tell me how to move."

The Los Angeles coast is a special place for Keon. "Venice Beach is my favorite outdoor skate spot because of the smooth concrete, palm trees, and warm sun. We also have great beach paths from Santa Monica to Redondo Beach."

Though she approached everything with zero expectations, skating is now her career as well. She has performed on stage with major artists such as Usher and Pink, and continues to dance and choreograph her own work. "I skate most days, but I have to take time for rest and recovery. When I'm home in L.A. I train, I teach, and, depending on the day, I am either on set for a commercial/film project or in rehearsals for upcoming performances." Her next passion project is planning a world tour, where she dreams to teach roller dancing around the globe. "I want to help people find their flow, whatever that means for them!"

Ballett und Modern Dance waren lange Zeit der Lebensinhalt von Keon Saghari. Mit drei Jahren begann die Ausbildung der gebürtigen Kalifornierin mit iranischen Wurzeln. Jahrelang tanzte sie auf amerikanischen und internationalen Bühnen – bis zu dem Punkt, an dem der Aufwand, den der Erfolg einforderte, die Freude am Tanzen überstieg. „Meine Prioritäten verlagerten sich, und meine Beziehung zum Tanz war nicht mehr so erfüllend wie zuvor."

Ein Leben ohne Bewegung war für Keon jedoch unvorstellbar, und so schnappte sie sich ein Paar Rollschuhe. „Ich habe damit begonnen, um meinen Körper weiterhin zu bewegen und um Musik auf ähnliche Weise wie beim Tanzen zu genießen, aber ohne den Druck und die emotionale Belastung." Skaten ist für sie ein Ganzkörpererlebnis. Ihre Choreografien sind geprägt von ihrer tänzerischen Vergangenheit. Sie fokussiert sich nicht nur auf die Schritte, sondern bringt auch Oberkörper und Arme mit ein. Ballett, Modern Dance, Jazz und zeitgenössischer Tanz: Ihr Stil ist eine Mischung aus allem, gepaart mit typischen Dance-Skating-Stilen wie dem JB und Jam Skating. „Ich folge nicht nur einem bestimmten Skate-Stil, sondern lasse die Musik bestimmen, wie ich mich bewege." Die Küste von Los Angeles ist für sie der beste Spot. „Der Strand von Venice ist mein Lieblingsplatz, wegen des glatten Betons, der Palmen und der Sonne. Wir haben auch tolle Strandpromenaden von Santa Monica bis Redondo Beach."

Zwar sei sie alles ohne Erwartungen angegangen, doch mittlerweile ist das Skaten auch ihr Beruf. Sie performt mit Superstars wie Usher und Pink auf der Bühne, tanzt und choreografiert. „Ich skate fast täglich, muss mir aber auch Zeit für Ruhe und Erholung nehmen. Wenn ich zu Hause in L. A. bin, trainiere und unterrichte ich, sonst bin ich entweder am Set für ein Werbe- oder Filmprojekt oder bei den Proben für bevorstehende Auftritte." Seit längerem plant sie eine Welttour, auf der sie rund um den Globus Roller Dancing unterrichten will. „Ich möchte Menschen helfen, ihren Flow zu finden, was auch immer das für sie bedeutet!"

KEON SAGHARI

@neonkeon
Los Angeles, CA, USA

ROLLER DANCE

Keon's past as a dancer shapes her signature
skating style.

Keons tänzerische Vergangenheit prägt ihren
unverkennbaren Skate-Stil.

Keon performing at Usher's 2022 Las Vegas
Residency.

Keon auf der Bühne bei Ushers 2022 Las Vegas
Residency.

As teenagers, Terron Frank and his cousin dreamed of becoming rappers. The only thing that remains from this dream is his nickname, T-Stacks, the alias everyone in the roller dancing world knows him by. At first, it was just a pastime, but it is a well-known fact that roller skating fever never lets go of you. "Skating means everything to me now. I can skate better than I can walk. With wheels under my feet, I feel absolute peace, joy, and happiness," he says.

When you see him dance, you can feel it. He gracefully glides across the floor almost like a figure skater, astonishing onlookers by spinning two dozen times in a row. He wears his skates loosely laced and bends his ankles outward and inward, sometimes standing on just two of the eight wheels. Before you know it, he dives into groundwork, which involves moves from breakdancing performed on the floor. Terron modestly describes his skating style as "a little bit of everything."

Several times a week, he makes the hour-long drive to Nashville for adult skate nights at the rinks. These disco nights are reserved for adults, allowing advanced skaters to fully display their skills. "The best rink in Nashville for adult soul skating is Rivergate Skate Center along with Brentwood Skate Center's Retro Night," he says. You can also sometimes find him at Two Rivers Skatepark or Sixth Avenue. Apart from that, he mainly travels to skate events in the U.S.

He always has his headphones with him. "Music is very important. It can make a skate night bad, good, or great." The genres he loves to skate to range from old school to funk to new school to house. He often skates alone. "I have kinda like a popular loner type of vibe," he says. Skating, however, has given him some amazing friendships throughout his travels. He still dreams of making it his profession someday.

Als Teenager träumten Terron Frank und sein Cousin davon, Rapper zu werden. Geblieben ist von diesem Traum sein Spitzname, T-Stacks, unter dem man ihn vor allem in der Roller-Dance-Szene kennt. Anfangs war es nur ein Zeitvertreib, doch das Rollschuhfieber lässt einen bekanntlich nicht mehr los. „Skaten bedeutet mir heute alles. Ich kann besser skaten als gehen. Wenn ich Rollen unter den Füßen habe, fühle ich absoluten Frieden, Freude und Glück", sagt er.

Sieht man ihn tanzen, kann man das spüren. Fast wie ein Eistänzer gleitet er anmutig über das Parkett, sorgt mit Pirouetten mit zwei Dutzend Umdrehungen für Staunen. Seine Skates trägt er nur locker geschnürt, biegt seine Knöchel nach außen und nach innen, manchmal steht er dabei gerade einmal auf zwei der acht Rollen, und ehe man sich versieht, taucht er ab ins Groundwork. Dazu gehören Moves aus dem Breakdance, die auf dem Boden stattfinden. Seinen Skate-Stil beschreibt Terron bescheiden als „ein bisschen von allem".

Mehrmals die Woche nimmt er die einstündige Autofahrt in Richtung Nashville in Kauf, weil es dort sogenannte Adult Nights in den Rinks gibt. Diese Disco-Abende sind Erwachsenen vorbehalten und erlauben es fortgeschrittenen Skatern, ihr Können voll auszuleben. „Die besten Rinks in Nashville für Soul Skating sind das Rivergate Skate Center und das Brentwood Skate Center mit seiner Retro Night", sagt er. Manchmal trifft man ihn auch im Skatepark Two Rivers oder im Sixth Avenue. Ansonsten reist er hauptsächlich zu Skate-Events in den USA.

Die Kopfhörer hat er immer dabei. „Musik ist sehr wichtig. Sie kann einen Skate-Abend schlecht, gut oder großartig machen." Genres, zu denen er tanzt, reichen von Old School bis Funk hin zu New School und House. Oft tanzt er allein. „Ich bin so etwas wie ein bekannter Einzelgänger", sagt er. Das Skaten brachte ihm auf seinen Reisen jedoch einige wunderbare Freundschaften. Es irgendwann einmal zu seinem Beruf zu machen, ist für ihn ein Traum, den er noch zu träumen wagt.

T-STACKS FRANK

@t_stackxz
Smithville/Nashville, TN, USA

Terron on the floor at his favorite rink Rivergate
Skate Center in Nashville, Tennessee.

Terron auf der Tanzfläche seines Lieblings-Rinks
Rivergate Skate Center in Nashville, Tennessee.

MICHELLE BARRIOS

@michelleptybcn
Barcelona, Spain

Panama is a country of misty rainforests and tropical beaches. Michelle Barrios, a native of the country, was nevertheless drawn by fate to Barcelona at some point. And the worldwide roller dance community is grateful to her. When the Catalan metropolis fills up with roller skaters from around the world in mid-September, it's because of the Skate Love Festival Michelle created.

You might say this is the life's work of the communication designer, though it began on a smaller level. "I started the BCN Roller Dance in 2011 to promote dancing on roller skates in Barcelona with small events and meetups, while getting inspired and connecting with other parts of the world through social media." The group used to meet at the W Barcelona Hotel beach promenade, a well-known hot spot for Barcelona's roller dancers. She posted pictures and videos from these meetups on social media, and shortly people around the world began to join them. "In the very beginning, there were few people, then 400," she recalls.

She organized the first festival under its current name in 2015, and it has continued to grow year after year since then. "Almost 2,000 skaters were there in 2022. I'm truly happy to see what the brand Skate Love Barcelona represents in the world, and especially what it means to our community." There is an open-air roller skating paradise on the beach called SkateLand, with food trucks, DJs, performances by international artists, master classes, plus a skate park event, street skating ... for many people it is the most amazing event there is. "I love that they come feeling free, motivated, and inspired. They come with an open heart to share with others."

For Michelle, the whole year and her life revolve around the festival. As soon as it's over, the planning for the next one begins. When she is able to carve out the time, the gifted dancer can be found with her friends at *Espigó de Bac de Roda* or, of course, outside the W Barcelona. "I love the energy this place has, as well as the nice sunsets. The floor could be better for skaters, but the social vibe is magical!"

Oh, wie schön ist Panama, titelte mal ein bekannter deutscher Autor. Die dort geborene Michelle Barrios verschlug das Schicksal dennoch irgendwann nach Barcelona. Und die weltweite Roller-Dance-Gemeinde dankt es ihr. Wenn sich die katalanische Metropole Mitte September mit Roller Skatern aus der ganzen Welt füllt, dann liegt das am Skate Love Festival, das Michelle erschaffen hat.

Man könnte sagen, es ist das Lebenswerk der Kommunikationsdesignerin, das klein angefangen hat. „2011 habe ich BCN Roller Dance gestartet. Ich wollte Tanzen auf Rollschuhen fördern und Leute weltweit vernetzen." Die Gruppe traf sich immer am Strand vor dem W Barcelona Hotel, ein bekannter Hotspot für Barcelonas Rollschuhtänzer. Sie postete Fotos dieser Treffen in den Sozialen Medien, und so wurden Menschen weltweit darauf aufmerksam. „Zuerst waren wir nur wenige, bald dann 400", erinnert sie sich.

2015 veranstaltete sie dann das erste Festival unter dem heutigen Titel. Seitdem wächst es Jahr um Jahr. „Fast 2000 Skater waren 2022 dabei. Es macht mich sehr glücklich, zu sehen, wofür die Marke Skate Love Barcelona weltweit steht, und wie viel sie unserer Gemeinschaft bedeutet." Es gibt ein Open-Air-Rollschuhparadies am Strand namens SkateLand, mit Food Trucks, DJs, Auftritten internationaler Künstler, Masterclasses, außerdem ein Skatepark-Event, Street Skating ... Für viele ist es das schönste Ereignis überhaupt. „Ich finde es großartig, dass alle sich frei, motiviert und inspiriert fühlen, und sich mit einem offenen Herz begegnen."

Für Michelle dreht sich das ganze Jahr, ihr Leben, um das Festival. Kaum ist es vorbei, beginnt die Planung für das nächste. Wenn sie die Zeit freischaufeln kann, dann trifft man die begnadete Tänzerin mit ihren Freunden am Espigó de Bac de Roda oder natürlich auf dem Plaza des W Barcelona an. „Ich liebe die Energie dieses Ortes, ebenso den schönen Sonnenuntergang. Der Bodenbelag könnte für die Skater besser sein, aber die Atmosphäre ist magisch!"

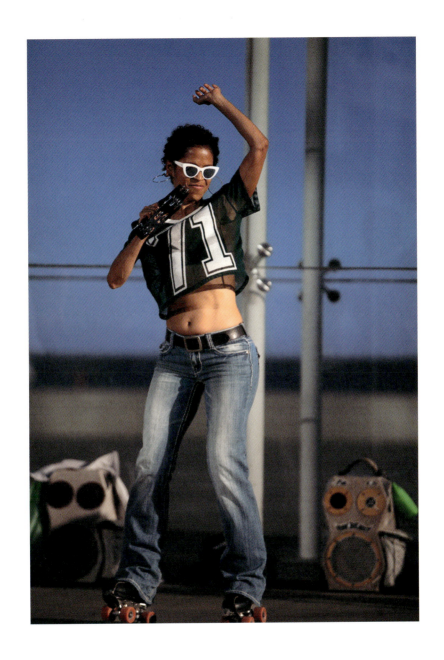

Michelle in a roller dance session at the popular spot
outside Barcelona's W Hotel.

Michelle bei einer Tanz-Session auf dem beliebten
Spot vor dem W Hotel in Barcelona.

RICHARD HUMPHREY

@richardhumphrey
San Francisco Bay Area,
CA, USA

Richard Humphrey is a living legend when it comes to roller dancing. More than 40 years ago, the San Francisco resident developed numerous steps and line dances, and these choreographed dances are still imitated by many skaters around the world today. The 70-year-old has been on roller skates since the early 1970s. He glides smoothly on eight wheels and has perfected every dance step over the decades.

Back when he started, people mainly got together at rinks to move to the music. "At that time, roller dance was starting to evolve, but we had no idea where it was going," he says. In the late 1970s, skaters in San Francisco began trying out different dance moves. "There was nobody to teach us, it was just our creativity." Eventually, they became dances.

They began to meet in Golden Gate Park starting in 1979. "We never did that before." It is important to remember that urethane wheels, which made skating on the asphalt enjoyable in the first place, had only recently become available. "There was not one predominant race of people in the park. It was everybody. We skated up and down John F. Kennedy Drive. All the people who knew how to do a little something were trying to show off and flaunt their skills. There were only a few of us, but our dance style started to evolve."

At the height of popularity, Richard formed a dance troupe called the Golden Rollers, who performed on television and in nightclubs. Richard developed the *Rollerdance Workout*, distributing it on VHS and later on DVD. Today, he posts videos on his social media channels. After so many decades, he still doesn't tire of teaching his steps and traveling the world. At Skate Love Barcelona, he is in demand as a dance coach. He feels it is nice to be good at something, but it is even nicer to pass your skills on. "When people say, 'Richard inspired me and taught me how to dance on skates', that's a good feeling."

Richard Humphrey ist eine lebende Legende, wenn es um Roller Dance geht. Vor mehr als 40 Jahren entwickelte der Mann aus San Francisco zahlreiche Schritte und Line Dances. Diese choreografierten Tänze ahmen viele Skater bis heute auf der ganzen Welt nach. Der 70-Jährige steht seit Beginn der 70er Jahre auf Rollschuhen. Smooth – geschmeidig – gleitet er auf acht Rollen dahin, jeden Tanzschritt hat er über die Jahrzehnte perfektioniert.

Als er anfing, traf man sich in erster Linie in Rinks, um sich dort zur Musik zu bewegen. „Zu jener Zeit begann sich der Rollschuhsport zu entwickeln, aber wir hatten keine Ahnung, wohin es gehen würde", sagt er. Ende der 70er Jahre begannen die Skater in San Francisco, verschiedene Tanzschritte auszuprobieren. „Es gab niemanden, der uns etwas beibrachte, alles entstand aus unserer Kreativität heraus." Irgendwann wurden es Tänze.

Ab 1979 traf man sich im Golden Gate Park. „Das haben wir davor nie gemacht." Man darf nicht vergessen, dass Rollen aus Urethan erst seit kurzem erhältlich waren und das Fahren auf dem Asphalt überhaupt erst angenehm machten. „Menschen aller Hautfarben kamen damals im Park zusammen, es kam einfach jeder. Wir rollten den John F. Kennedy Drive rauf und runter. Alle, die etwas konnten, versuchten, ihr Können zur Schau zu stellen. Wir waren nur wenige, aber unser Tanzstil begann sich zu entwickeln."

Auf dem Höhepunkt der Popularität gründete Richard eine Tanzgruppe: Die Golden Rollers traten im Fernsehen und in Nachtclubs auf. Richard entwickelte das *Rollerdance-Workout*, vertrieb es auf VHS, später auf DVD. Heute stellt er die Videos auf seine Social-Media-Kanäle. Auch mit seinen 70 Jahren ist er nicht müde, seine Schritte zu unterrichten und um die Welt zu reisen. Beim Skate Love Barcelona ist er als gefragter Tanzlehrer dabei. Es sei schön, etwas gut zu können, aber noch schöner sei es, Fähigkeiten weiterzugeben. „Wenn Leute dann sagen: Richard hat mich dazu inspiriert und man diese Anerkennung erhält, dann ist das ein großartiges Gefühl."

Skaters at Skate Love Barcelona are excited to
dance with and learn from roller dance legend
Richard Humphrey.

Die Tänzer auf dem Skate Love Barcelona freuen
sich, mit der Roller-Dance-Legende Richard
Humphrey gemeinsam zu tanzen und von ihm zu
lernen.

Richard (left) and the
Golden Rollers.

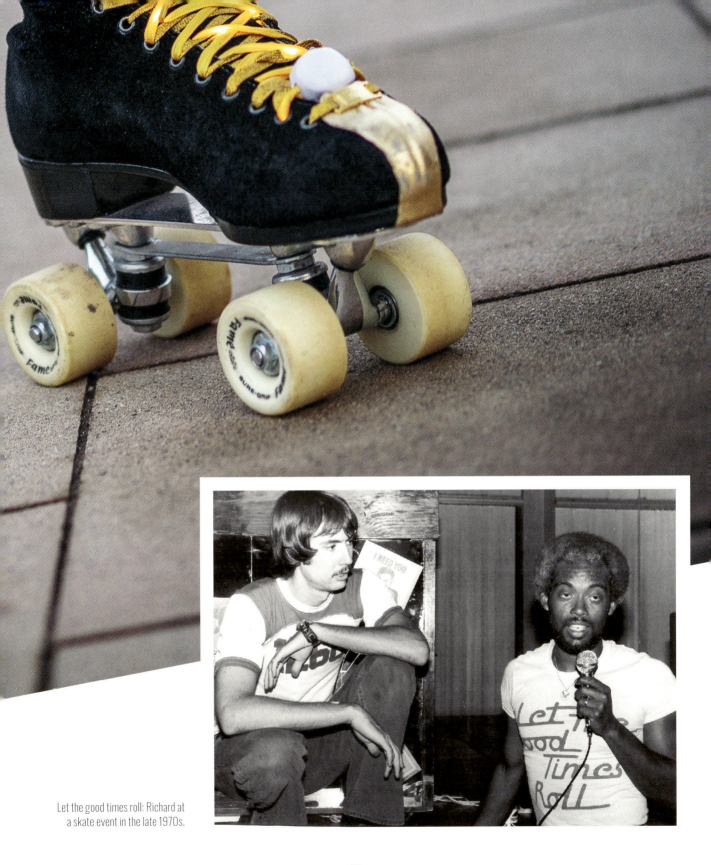

Let the good times roll: Richard at a skate event in the late 1970s.

For her 30th birthday, her siblings gave her a pair of roller skates. Shari Kim Kleinlugtenbelt had been raving to them about Chet Faker's music video for the song "Gold". In it, professional skater Candice Heiden skates down a road at night, mesmerizing the viewer with her moves in the headlights. "I was like, wow, that's so freaking hot. I want to be able to do that," Shari says, laughing.

At first, though, she was hesitant, despite being used to having an audience: When she was younger, she used to dance hip-hop and play basketball. In 2020, in the middle of the pandemic, Instagram and the like were flooded with so many roller skating videos that she decided to take the plunge. In her adopted city of Munich, she went by herself to the *Theresienwiese* and encountered a jam skater there. She joined her. Week after week, more and more skaters came along.

Shari was amazed by the openness of the people. In the first year, she skated four to five times a week. "The *Wiesn* offers an incredible amount of space. It's like a beer garden. Everyone joins in, there are no barriers, we all offer to help each other." From beginners to pros, it is a diverse community. "If you don't like the music, just put your headphones on and stay anyway." Sometimes everyone skates on their own – but never alone.

The roller skates give her the freedom to dance outside without anyone giving her a funny look. Munich is not L.A. "If you didn't have skates on, people here would probably think you were drunk." But this way, everyone feels like they belong, and they usually have a smile for her. Shari shares her joy of dancing on eight wheels with her more than 50,000 followers on her Instagram channel. She is being interviewed for magazines such as *Women's Health* and in demand for music videos or advertising shoots, like the one for Daller Tracht (picture on the right). The relaxed skater projects a sense of approachability. "Girls write to me that they started roller skating because of me." Many are in their mid-30s like her, she says. "They never thought they'd get started with it at this point."

Zum 30. Geburtstag schenkten ihr ihre Geschwister ein Paar Rollschuhe. Shari Kim Kleinlugtenbelt hatte ihnen von Chet Fakers Musikvideo zum Song *Gold* vorgeschwärmt. Darin tanzt die professionelle Skaterin Candice Heiden eine nächtliche Straße entlang und hypnotisiert dabei mit ihren Bewegungen im Scheinwerferlicht. „Ich dachte, Alter, das ist so verdammt hot. Das will ich auch können", sagt Shari und lacht.

Zunächst habe sie sich aber nicht getraut, obwohl sie Zuschauer gewohnt war: In jungen Jahren hatte sie Hip-Hop getanzt und Basketball gespielt. 2020, inmitten der Pandemie, waren Instagram und Co. derart übersät von Roller-Skate-Videos, dass sie sich doch einen Ruck gab. Die Wahlmünchnerin ging allein auf die Theresienwiese und traf dort eine Jam Skaterin. Sie schloss sich ihr an. Woche für Woche kamen immer mehr Skater dazu.

Shari war begeistert von der Offenheit der Leute. Im ersten Jahr skatete sie vier bis fünf Mal die Woche. „Die Wiesn bietet unheimlich viel Fläche, sie ist wie ein Biergarten, da kommt jeder dazu, es gibt keine Barriere, jeder hilft jedem." Von der Anfängerin bis zum Profi sei es eine vielfältige Gemeinschaft. „Wenn einem die Musik nicht gefällt, dann zieht man seine Kopfhörer auf und bleibt trotzdem." So tanzt auch mal jeder für sich – aber nie allein.

Die Rollschuhe geben ihr die Freiheit, draußen zu tanzen, ohne blöd angeschaut zu werden. München ist nun mal nicht L. A.: „Hätte man keine Skates an, würden die Leute hier zumindest denken, man sei betrunken." Aber so fühle sich jeder abgeholt und habe meist ein Lächeln für sie übrig. Auf ihrem Instagram-Kanal teilt Shari ihre Freude am Tanzen auf acht Rollen mit mehr als 50 000 Followern. Sie wird von Magazinen wie *Women's Health* interviewt, für Musikvideos (The BossHoss) und Werbeshootings, zum Beispiel für Daller Tracht (Foto rechts), angefragt. Die entspannte Badnerin vermittelt Nahbarkeit. „Mir schreiben Mädels, dass sie wegen mir mit Rollschuhlaufen angefangen haben." Viele seien wie sie Mitte 30. „Die hätten nie daran gedacht, dass sie noch damit anfangen."

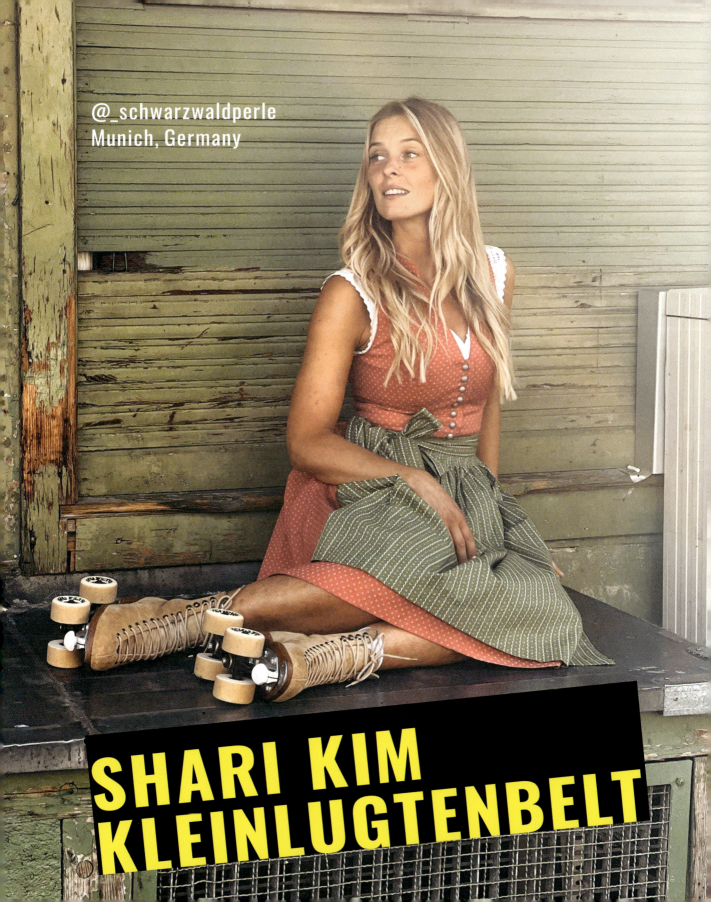

@_schwarzwaldperle
Munich, Germany

SHARI KIM
KLEINLUGTENBELT

Shari at Munich's most popular skating spot, the *Theresienwiese*, where the world-famous Oktoberfest is held every year.

Shari auf Münchens beliebtestem Skate-Spot, der Theresienwiese. Hier findet jedes Jahr das weltberühmte Oktoberfest statt.

ROLLER DANCE

KEEGAN SHIM

@shimshimmaa
Toronto, Canada

"I would definitely recommend visiting the rink," says Keegan Shim. For him, it is the place to experience the true vibe of roller skating. When you think of Toronto, you don't necessarily think of roller dance. But there's more action happening on eight wheels in Canada's largest metropolis than you might think. "There's the community of people who've been skating for 20 or even 40 years. And then you have the new generation, skaters who started during the pandemic," he says. During lockdowns, people would meet outside at Greenwood Park, Riverdale Park, College Park, or Pier 8.

It wasn't all that many years ago that Keegan himself discovered his love of roller skating. The fact that he moves so smoothly on eight wheels isn't just because he practices five times a week, it also stems from his roots as a dancer. He has been dancing since his teens, learning styles such as Locking, House, Hip-Hop and partner dances such as the Hustle. The combination of these styles was ideal for him to transfer to roller skates.

And yet it took a while for something to light the fire. "Roller skating was something I'd seen in movies or if I went to New York, to Central Park. I remember being so inspired. But for me, I never knew … I thought to myself, I could never do that," he said. Hearing many of his dance teachers recount how they had skated in roller rinks when they were younger, curiosity finally got the best of him. "I fell in love right away." That was in late 2018, and he hasn't stopped skating since. "I practiced all the time, at lunchtime and in the evening. And when I went home, I still put on my skates and practiced until three in the morning. I was obsessed."

All that work has paid off. Today, Keegan teaches other roller skating enthusiasts. He travels to events including Skate Love Barcelona and visits the birthplace of rhythm skating, the U.S. This is where the wide range of styles have evolved: Jam skating, JB style in Chicago with its light-footed fast footwork, or the skating duos, trains and trios you can see in New York/New Jersey. He would like the people who are inspired by those moves on TikTok and Instagram to know and honor their roots.

"Ich würde immer einen Besuch im Rink empfehlen", sagt Keegan Shim. Es sei der Ort, an dem man den wahren Vibe des Roller Skatens erleben könne. Bei Toronto denkt man nicht unbedingt an Roller Dance. Doch in der größten kanadischen Metropole passiert mehr auf acht Rollen, als man meint. „Hier sind Leute, die schon seit 20 oder gar 40 Jahren skaten, und eben die neue Generation, die seit der Pandemie wächst", sagt er. Während der Lockdowns traf man sich draußen im Greenwood Park, Riverdale Park, College Park oder am Pier 8.

Keegan selbst entdeckte seine Liebe zu Rollschuhen vor wenigen Jahren. Die Tatsache, dass er sich auf acht Rollen derart geschmeidig bewegt, liegt nicht nur daran, dass er fünf Mal die Woche trainiert, sondern ist auch in seinen Wurzeln als Tänzer begründet. In Teeangerjahren lernte er Locking, House, Hip-Hop und Partnertänze wie den Hustle. Die Kombination dieser Tanzstile ließ sich wunderbar auf Rollschuhe übertragen.

Und doch dauerte es, bis etwas das Feuer entzündete. „Ich kannte es natürlich aus Filmen oder Besuchen im New Yorker Central Park. Es war inspirierend, aber irgendwie dachte ich nie, dass ich das könnte", sagt er. Doch weil viele seiner Tanzlehrer immer wieder davon erzählten, wie sie in jungen Jahren in Roller Rinks geskatet hatten, packte ihn die Neugier schließlich doch. „Ich habe mich sofort verliebt." Das war Ende 2018, und seitdem hat er mit dem Skaten nicht mehr aufgehört. „Ich ging jede freie Minute üben, in der Mittagspause und am Abend. Und als ich nachhause ging, zog ich meine Skates wieder an und übte bis drei Uhr morgens. Ich war so besessen."

Die Arbeit hat sich ausgezahlt. Heute unterrichtet Keegan andere Rollschuhbegeisterte. Er reist zu Events wie dem Skate Love Barcelona und in die USA, das Geburtsland des Rhythm Skatings. Dort haben sich die vielen Stile entwickelt, sei es Jam Skating, der JB Style in Chicago mit seiner leichtgängigen, schnellen Fußarbeit oder die Paarformation, wie man sie in New York/New Jersey sieht. Er wünscht sich, dass die Menschen auf TikTok und Instagram, die sich von den Bewegungen inspirieren lassen, ihre Wurzeln kennen und würdigen.

Keegan's skating style is influenced by his past as a dancer. Here he is at Skate Love Barcelona 2022.

Keegans Skate-Stil ist geprägt von seiner Vergangenheit als Tänzer. Hier auf dem Skate Love Barcelona 2022.

By the age of 18, Amy Rainbow had achieved everything possible in artistic roller skating. She had won the British Championships three times in a row. And with that, it somehow felt like it was all over. There were no goals left to reach for. "Artistic roller skating is not an Olympic sport. So it's quite common to quit when you reach early adulthood, and go live a normal life."

But Amy found it hard to hang up her roller skates, because she has loved moving around and dancing in them since first putting them on at the age of seven. Her family, she says, has always been amazed at her huge obsession with roller skating. "But especially my mom supported me during every practice, every trial and every competition, even if she couldn't always afford it."

Amy put her sport before everything else, practicing up to 15 hours a week for a good ten years, getting up every morning long before school started to go for a run, to stretch. "Despite the many, many broken bones along the way, I just loved the freedom I experienced every time I laced up my skates, the rush of adrenaline every time I entered a jump at full speed. I was truly at peace and whatever was going on in my life simply dissolved away into nothing."

She considers it her own incredibly good fortune that skating has grown so much in popularity during the pandemic. "I have been waiting for this moment my entire life! When I started skating back in the early 2000s, roller skating popularity was at an all-time low." Her friends at school considered it uncool. "Despite being the UK Champion, I was teased at school for not competing in a 'real sport'." Looking back, the 22-year-old is happy she didn't listen to the comments. She makes a living performing in music videos and TV commercials, and teaching artistic roller skating. But the best part, she says, is the wonderful community filled with creativity and passion.

Mit 18 Jahren hatte die Britin Amy Rainbow alles erreicht, was im Rollkunstlauf möglich war. Drei Mal in Folge gewann sie die britische Meisterschaft. Damit war alles irgendwie vorbei. Höhere Ziele gab es nicht mehr. „Rollkunstlauf ist keine olympische Sportart. Es ist daher üblich, dass man im frühen Erwachsenenalter aufhört und ein normales Leben führt."

Die Rollschuhe an den Nagel zu hängen, fiel ihr jedoch schwer, denn Amy liebt es, sich darin fortzubewegen und zu tanzen, seit sie im Alter von sieben Jahren das erste Mal welche anzog. Ihre Familie sei immer erstaunt gewesen über ihre enorme Besessenheit vom Rollschuhlaufen. „Vor allem meine Mutter hat mich aber bei jedem Training, jeder Prüfung und jedem Wettkampf unterstützt, auch wenn sie es sich nicht immer leisten konnte."

Amy hatte alles dem Sport untergeordnet, gut zehn Jahre lang trainierte sie bis zu 15 Stunden die Woche, stand jeden Morgen lange vor Schulbeginn auf, um zu laufen, sich zu dehnen. „Trotz der vielen gebrochenen Knochen liebte ich die Freiheit, die ich fühlte, wenn ich meine Rollschuhe schnürte, den Adrenalinstoß, wenn ich mit voller Geschwindigkeit in einen Sprung ging. Ich war in einem Zustand innerer Ruhe, und was auch immer in meinem Leben los war, löste sich einfach in Nichts auf."

Sie sieht es als großes persönliches Glück, dass Skaten während der Pandemie derart an Beliebtheit gewonnen hat. „Auf diesen Moment habe ich mein ganzes Leben lang gewartet! Als ich Anfang der 2000er Jahre damit anfing, war die Popularität des Rollschuhsports auf einem absoluten Tiefpunkt." Er galt unter ihren Schulfreunden als uncool. „Obwohl ich britische Meisterin war, wurde ich in der Schule gehänselt, weil ich keinen ‚richtigen' Sport betrieb." Heute ist die 22-Jährige froh, nicht auf die Kommentare gehört zu haben. Sie lebt von Auftritten in Musikvideos, TV-Spots und unterrichtet Rollkunstlauf. Das Beste ist für sie aber die wunderbare Gemeinschaft voller Kreativität und Leidenschaft.

AMY RAINBOW

@amyrainbowskates
Ipswich, UK

AMY RAINBOW

While dancing, the three-time British artistic roller skating champion feels as free and light as a bird.

Beim Tanzen fühlt sich die dreifache britische Meisterin im Rollkunstlauf frei und leicht wie ein Vogel.

AMY RAINBOW

Nicole Adamczyk was actually just looking for an alternative to ice skating for the summer. It was always several months before the enthusiastic figure skater could wear blades under her shoes again. One day she picked up a pair of roller skates, not suspecting the enduring love affair that would unfold. Soon, the Munich native with the distinctive blue bob haircut and colorful outfits began to combine elements from classic skating with those from roller dancing.

Initially skating alone in 2015, she is still roller skating eight years later. Rhythm skating also gained popularity in Germany during the pandemic. Munich's first roller skating disco – since the closure of the legendary *Rollpalast* in 2005 – has been received with great enthusiasm by skaters of all ages.

For Nicole, skating means disconnecting, finding inner peace, freeing her mind from worries and everyday life. "When you lose yourself in the music and the flowing movements, it's a feeling of absolute freedom and bliss," she says. The soundtrack of her happiness is supplied by music from the 1970s and 1980s. Anyone walking along the *Theresienwiese* on a balmy summer evening, perking their ears at the sound of Earth, Wind & Fire, The Jacksons, or Kool & The Gang, will very likely come across a group of roller skaters dancing or rehearsing choreography together.

"Something that is special about roller skaters is that there is a global community that exchanges ideas and meets up regularly in cities. That's sensational. In the past, I would never have thought it possible that people would absolutely want to visit other skaters to learn from them." The Skate Love Festival in Barcelona is an annual highlight for the Munich resident. "Coco Beach in Badalona is phantastic. The beach promenade in Barcelona is also awesome." Venice Beach is still on her wish list, and Nicole always skates wherever she goes on vacation. After all, you can find beautiful spots for skating everywhere.

Eigentlich suchte Nicole Adamczyk nur nach einer Alternative zum Schlittschuhlaufen für den Sommer. Denn bis die begeisterte Eistänzerin wieder Kufen unter den Schuhen tragen konnte, vergingen immer mehrere Monate. So griff sie eines Tages zu einem Paar Rollschuhe, ohne zu ahnen, welche innige Liebe entstehen würde. Schon bald begann die Münchnerin mit dem markanten blauen Bob und den kunterbunten Outfits, Elemente aus dem klassischen Eislauf mit jenen aus dem Roller Dance zu verbinden.

2015 zunächst allein, rollt sie acht Jahre später noch immer. Das Rhythm Skating hat auch in Deutschland während der Pandemie großen Zulauf bekommen: München's erste Rollschuhdisco – seit der Schließung des legendären Rollpalasts im Jahr 2005 – wird mit großer Begeisterung von Läufern allen Alters aufgenommen.

Skaten bedeutet für Nicole abzuschalten, innere Ruhe zu finden, den Kopf von Unsicherheiten und Alltag zu befreien. „Wenn man sich in der Musik und den fließenden Bewegungen verliert, ist das ein Gefühl von absoluter Freiheit und Glückseligkeit", sagt sie. Den Soundtrack zum Glück liefert ihr Musik der 70er und 80er Jahre. Wer an einem lauen Sommerabend an der Theresienwiese spazieren geht, die Ohren spitzt und von weitem den Sound von Earth, Wind & Fire, The Jacksons oder Kool & The Gang vernimmt, wird höchstwahrscheinlich auf eine Gruppe Roller Skater treffen, die tanzen oder gemeinsam Choreographien einstudieren.

„Etwas Besonderes bei den Rollschuhläufern ist, dass es eine weltweite Community gibt, die sich austauscht und regelmäßig in Städten trifft. Das ist sensationell. Ich hätte früher nie für möglich gehalten, dass man unbedingt andere Skater besuchen möchte, um von ihnen zu lernen." Das Skate Love Festival in Barcelona gehört für die Münchnerin zum jährlichen Highlight. „Coco Beach in Badalona ist fantastisch. Die Strandpromenade in Barcelona ist ebenfalls mega." Venice Beach steht noch auf der Wunschliste, ansonsten rollt Nicole überall dort, wo sie Urlaub macht. Schöne Ecken zum Skaten finden sich schließlich immer und überall.

@rollin_me_softly
Munich, Germany

NICOLE
ADAMCZYK

The former figure skater loves life on
eight wheels and is an influential
figure in Munich's roller skating scene.

Die ehemalige Eistänzerin liebt das
Leben auf acht Rollen und ist ein
wichtiger Magnet für Münchens
Rollschuhszene.

PARKING

PARK

SKATIING

S kates are the shoes of the future, not of the past."
Michelle Steilen has repeated this sentence many
times, and it is probably truer for her than for anyone
else who turned their passion into a career.

After graduating from college in 2005, she moved from
the East Coast city of Philadelphia to Long Beach,
California, a one-way ticket in her bag. She began her
roller derby career as Estro Jen, opened a roller skate
store and, with a great deal of convincing, talked re-
nowned roller skate manufacturer Riedell into making
her colorful Moxi skates.

It is a story she has told countless times, but it is worth
telling again, because it unleashed something in girls
and women; something many of them were unaware
was not just dormant in boys and men, but could also be
found within themselves. Michelle Steilen not only
makes beautiful roller skates, she also skates radically
while wearing them, hurling herself down the steps
outside the nearest supermarket instead of cruising
leisurely down the street. Her backflips in half-pipes
leave mouths agape.

Michelle's Moxi roller skates have become an iconic
brand. Available in all the colors of the rainbow, the
boots are the epitome of the Californian lifestyle that
people in Berlin or Paris also yearn for. Both experi-
enced skaters and style-conscious beginners love these
retro high-top skates.

During the pandemic, when many were discovering
outdoor sports for themselves, the sales figures of roller
skates skyrocketed. "Not too long ago, Moxi Roller
Skates was a tiny business with giant dreams," Michelle
says. An ordinary garage was used for roller skate stor-
age, now a thing of the past. Today, she divides her time
between Long Beach and her country estate north of
Los Angeles. The property is a playground for adults,
welcoming visitors with a small animal park and a
concrete skate park in the front yard, and a perfect
half-pipe behind the house in the heart of the green
countryside – a skater's dream!

R oller Skates sind die Schuhe der Zukunft, nicht der
Vergangenheit." Diesen Satz hat Michelle Steilen
schon häufig gesagt. Für niemanden ist er vermutlich
so wahr wie für sie, die ihre Leidenschaft zum Beruf
gemacht hat.

Nach ihrem Uniabschluss 2005 zog sie aus Philadelphia
an der Ostküste ins kalifornische Long Beach. In der
Tasche hatte sie nur ein One-Way-Ticket. Als Estro Jen
startete sie ihre Roller-Derby-Karriere, eröffnete ein
Rollschuhgeschäft und brachte mit viel Überzeugungs-
arbeit den renommierten Rollschuhhersteller Riedell da-
zu, ihre bunten Moxi Skates zu fertigen.

Die Geschichte hat sie schon unzählige Male erzählt,
aber sie ist erzählenswert, weil sie etwas bei Mädchen
und Frauen losgetreten hat. Etwas, von dem viele nicht
wussten, dass es nicht nur in Jungs und Männern, son-
dern auch in ihnen schlummert. Denn Michelle Steilen
macht nicht nur wunderschöne Rollschuhe, sie skatet
darin auch radikal. Sie stürzt sich die Treppenstufen
vor dem nächsten Supermarkt hinunter, anstatt die
Straße einfach gemächlich entlangzurollen. Ihre Back-
flips in Halfpipes sorgen für offene Münder.

Michelles Moxi Roller Skates sind heute eine Kult-
marke. Die in allen Farben des Regenbogens erhältlichen
Stiefel sind der Inbegriff des kalifornischen Lebens-
gefühls, das die Menschen in Berlin oder Paris ebenfalls
haben wollen. Die Retro-High-Top-Skates lieben sowohl
erfahrene Skater als auch modebewusste Anfängerinnen.

Während der Pandemie, als viele die Outdoor-Sport-
arten für sich entdeckten, explodierten auch die Zahlen
der Rollschuhverkäufe. „Vor nicht allzu langer Zeit war
Moxi Roller Skates ein kleines Business mit Riesen-
träumen", sagt Michelle. Eine gewöhnliche Garage dien-
te als Rollschuhlager. Das ist passé. Heute lebt sie mal in
Long Beach, mal auf ihrem Landsitz nördlich von Los
Angeles. Das Grundstück ist ein Spielplatz für Erwach-
sene. Es empfängt Besucher mit einem kleinen Tierpark
sowie einem Beton-Skatepark als Vorhof und hinter
dem Haus mit einer perfekten Halfpipe mitten im Grü-
nen. So sehen Skaterträume aus!

@estrojen
Long Beach, CA, USA

MICHELLE
STEILEN

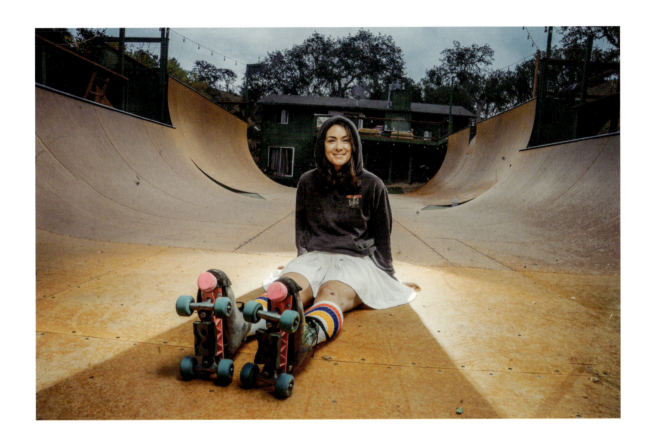

The Moxi founder and gifted park
skater in her backyard skate park.

Die Moxi-Gründerin und begnadete
Park Skaterin in ihrem Skatepark
hinter dem Haus.

A miniature horse in the animal park at
Michelle's home.

Ein Zwergpony in Michelles
hauseigenem Tierpark.

Estro and her girl gang on the streets of Las Vegas.
From left: CeCe Skatefantacee, Isabelle Ringer, Arshlynne,
SoraSupernova, and Ivey Rose.

Estro und ihre Girl Gang auf den Straßen von Las Vegas.
Von links: CeCe Skatefantacee, Isabelle Ringer, Arshlynne,
SoraSupernova und Ivey Rose.

Barbara "Barbie" Luciana Arganaraz is one of the few professional street and park skaters who is able to make a living from the sport and have the great fortune to travel the world. She is the first skater to have a pro-model roller skate, that is, a model from her sponsor Chaya featuring her name. She didn't push it, nor did she try to make money with it. "You have to have a dream, but don't put all your expectations in the result." If you spend all your energy making sure everything happens a certain way, you will destroy the dream, she believes.

As a kid she was competing in artistic roller skating, and her mother couldn't buy her better skates. "I cried, saying I needed new roller skates," recalls Barbie. But her mother responded with, "A pair of roller skates doesn't make the skater. Go skate, you can do it."

Today she is grateful for that lesson. "I really want to get the message out that if you want to skate, you can do it in any kind of boot." The 29-year-old Argentina native continues to live and skate by this creed to this day. At some point she had abandoned roller skating, but in her early twenties she spotted young women on roller skates in a skate park in her hometown of Buenos Aires, prompting her to get hers back out.

Barbie is driven to continuously raise her skating technique to the next level. Leaping down more stairs, conquering higher railings – whatever the urban environment throws at her, she accepts the challenge. That also includes dealing with fear. "I used to be a very nervous person. I didn't know how to breathe. I didn't take time to visualize." With practice, she learned how to do both. That also changed her as a person, she says, which is why she always stresses that skating is also a way of life. "I am very blessed and I've been to a lot of countries in a short time. It's always a mystery – I never know where I am going to go until the opportunity arrives and I take it." The one constant, she says, is roller skating, which guides her through life.

Barbara "Barbie" Luciana Arganaraz gehört zu den wenigen professionellen Street und Park Skaterinnen, die von dem Sport leben können und das Glück haben, die Welt zu bereisen. Sie ist die erste Skaterin, die einen Pro-Model-Rollschuh hat, also ein Modell ihres Sponsors Chaya, das ihren Namen trägt. Forciert hat sie das nicht, ebenso wenig wie damit Geld zu verdienen. „Man muss einen Traum haben, aber man darf nicht alle Erwartungen auf das Ergebnis setzen." Verwende man die ganze Energie darauf, dass alles auf eine bestimmte Weise geschehe, zerstöre man den Traum.

Als Kind war sie im Rollkunstlauf aktiv, und ihre Mutter konnte ihr keine besseren Stiefel kaufen. „Ich weinte, sagte, ich bräuchte neue Rollschuhe", erinnert sich Barbie. Doch ihre Mutter entgegnete: „Ein Paar Rollschuhe machen noch keine gute Läuferin. Geh skaten, du kannst das."

Heute ist sie dankbar für die Lektion. „Meine Botschaft ist, dass man in jedem Schuh skaten kann, wenn man nur will." Nach diesem Kredo lebt und skatet die 29-jährige Argentinierin bis heute. Dem Rollkunstlauf hatte sie irgendwann den Rücken gekehrt, doch mit Anfang 20 beobachtete sie in ihrer Heimatstadt Buenos Aires junge Frauen auf Rollschuhen in einem Skatepark und holte ihre wieder hervor.

Barbie ist getrieben davon, ihr Skaten technisch stetig auf das nächste Level zu heben. Mehr Treppen hinunterspringen, höhere Geländer bezwingen – was immer die urbane Umgebung ihr vorsetzt, sie nimmt die Herausforderung an. Dazu gehört auch, mit Angst umzugehen. Denn die sei immer dabei. „Ich war früher sehr nervös. Ich wusste nicht, wie ich atmen sollte. Ich habe mir keine Zeit genommen, um zu visualisieren." Mit Übung hat sie beides gelernt. Das habe sie auch als Mensch verändert, weshalb sie stets betont, dass Skaten auch ein Lebensstil sei. „Ich schätze mich glücklich. Ich habe in kurzer Zeit viele Länder bereist. Dabei weiß ich nie, wohin ich gehen werde, bis sich die Gelegenheit ergibt und ich sie ergreife." Die Konstante sei dabei das Roller Skaten, das sie durchs Leben leite.

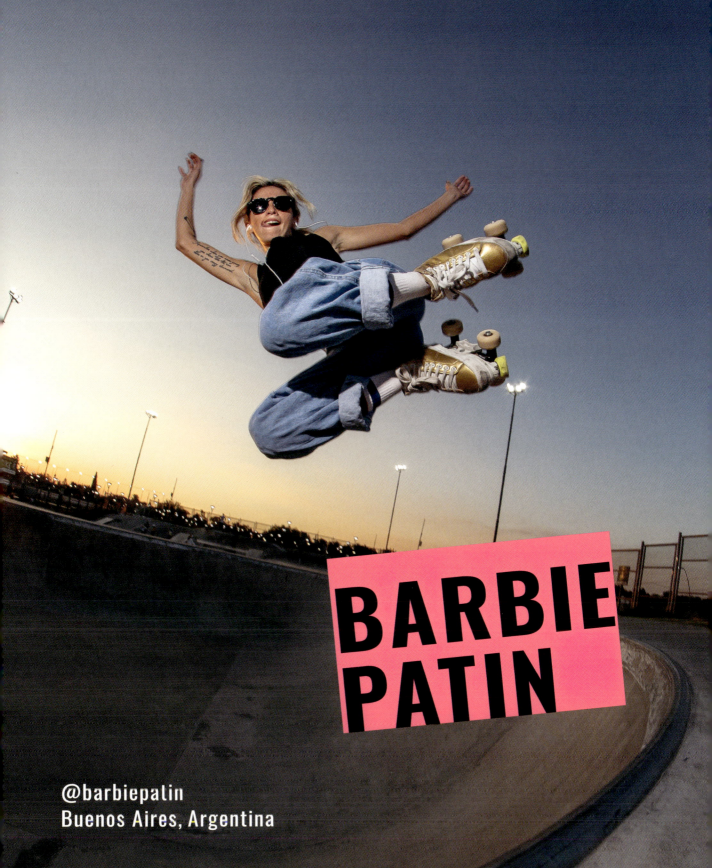

BARBIE
PATIN

@barbiepatin
Buenos Aires, Argentina

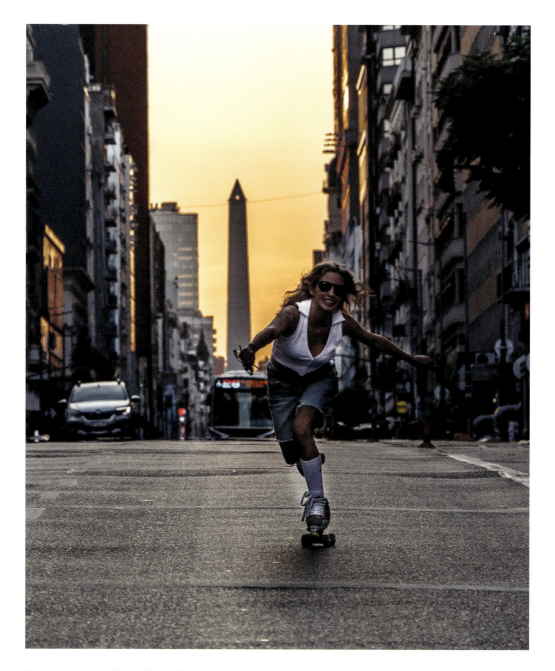

Barbie on the streets of Buenos Aires, with the city's
landmark Obelisk in the background.

Barbie auf den Straßen von Buenos Aires, im
Hintergrund der Obelisk, das Wahrzeichen der Stadt.

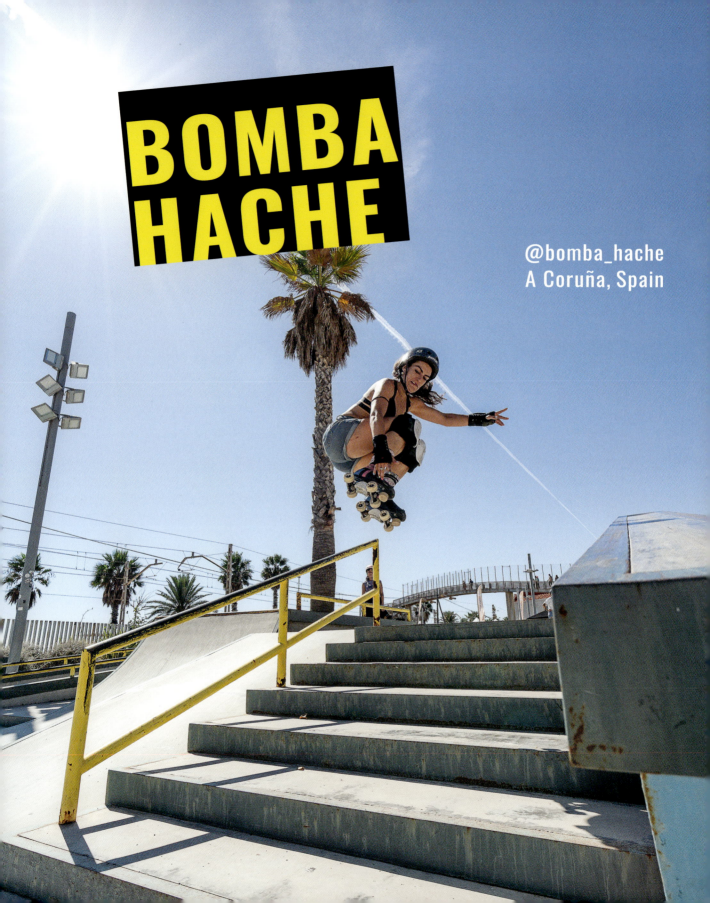

BOMBA
HACHE

@bomba_hache
A Coruña, Spain

She doesn't bother introducing herself under her given name, Sara Helena. The skating universe and her fans only know her as Bomba Hache. When you see the Spanish skater from A Coruña, Galicia, the source of her alias is obvious. Her style is explosive and dynamic. Freestyle, she calls it. She doesn't like to see a label forced on her way of skating.

As a child, she internalized the ability to jump and to perform precise spins in artistic roller skating lessons. Then, as a teenager, she lost interest in the regimented style of club sports, devoting her time to music and singing. "At some point, however, my vocal cords were ruined," she says with a husky timbre. To distract herself, she hauled her roller skates back out of the closet, heard about the local roller derby team and joined it. "One day a roller derby mate showed me a street video and my eyes opened wide," she says, immediately realizing, "That's exactly what I'm looking for!"

Until then, she had been unaware that there was a skate park in her town. She liked to skate around the downtown area, where she felt inspired by watching the skateboarders and scooter riders. She was the only one on roller skates there. "People's reactions to my roller skating were diverse. Some were surprised, others were making fun, but there was a lot of curiosity more than anything else."

Ten years later, she is one of the most famous park skaters in the world. On her Instagram channel, she shows the world her spectacular tricks, along with the falls, injuries, and rigorous training needed to get back in shape and stay that way. Roller skating is literally her life. She travels around Europe, holding workshops at home and abroad.

One thing she shares with everyone is that you shouldn't put up barriers in your mind. "Freestyle skating is about setting your own times, goals, and limits." It's not just about what you can do on skates; perseverance, commitment, and a positive mindset go a long way toward progress. Being scared is OK. "What matters is how you face your fears."

Unter ihrem bürgerlichen Namen Sara Helena stellt sie sich erst gar nicht vor. Das Skate-Universum und ihre Fans kennen sie nur als Bomba Hache. Sieht man die Spanierin aus dem galizischen A Coruña skaten, wird klar, woher das Alias stammt. Explosiv und dynamisch ist ihr Stil. Freestyle, nennt sie es selbst. Sie sieht ihre Art zu Skaten ungern in Schubladen gepresst.

Die Sprungkraft und die präzisen Drehungen hat sie im Kindesalter im Rollkunstlauftraining verinnerlicht. Als Jugendliche verlor sie die Lust am reglementierten Vereinssport und widmete sich der Musik und dem Gesang. „Irgendwann waren aber meine Stimmbänder ruiniert", sagt die Frau mit dem rauen Timbre. Zur Ablenkung holte sie die Rollschuhe wieder aus dem Schrank, hörte vom lokalen Roller-Derby-Team und schloss sich ihm an. „Eine Mitspielerin zeigte mir auf YouTube ein Street-Skate-Video", sagt sie. Ihr sei sofort klar gewesen: „Das ist es, wonach ich suche."

Sie hatte bis dahin nicht gewusst, dass es in ihrer Stadt einen Skatepark gibt. Sie skatete gern im Stadtzentrum und ließ sich von den Skateboardern und Rollerfahrern inspirieren. Auf Rollschuhen sah man dort außer ihr niemanden. „Die Reaktionen der Leute waren unterschiedlich. Manche waren überrascht, andere lachten darüber, viele aber waren vor allem neugierig."

Zehn Jahre später zählt sie zu den bekanntesten Park Skaterinnen der Welt. Auf ihrem Instagram-Kanal zeigt sie nicht nur die spektakulären Tricks, sondern auch die Stürze, Verletzungen und das harte Training, um wieder fit zu werden und es zu bleiben. Rollschuhlaufen, das ist buchstäblich ihr Leben. Sie reist durch Europa, gibt Workshops im In- und Ausland.

Mit auf den Weg gibt sie jeder und jedem, dass man sich im Kopf keine Barrieren setzen dürfe. „Im Freestyle Skaten geht es darum, seine eigenen Zeiten, Ziele und Grenzen zu stecken." Es sei nicht ausschließlich wichtig, was man auf Rollschuhen könne. Durchhaltevermögen, Einsatz und eine positive Einstellung hätten einen großen Einfluss auf den Fortschritt. Es sei in Ordnung, Angst zu haben. „Worauf es ankommt, ist, wie man ihr begegnet."

Bomba Hache at the iconic Mar Bella skate park in Barcelona,
a pilgrimage destination for skaters from all over the world.

Bomba Hache im ikonischen Skatepark Mar Bella in Barcelona,
zu dem Skater aus der ganzen Welt pilgern.

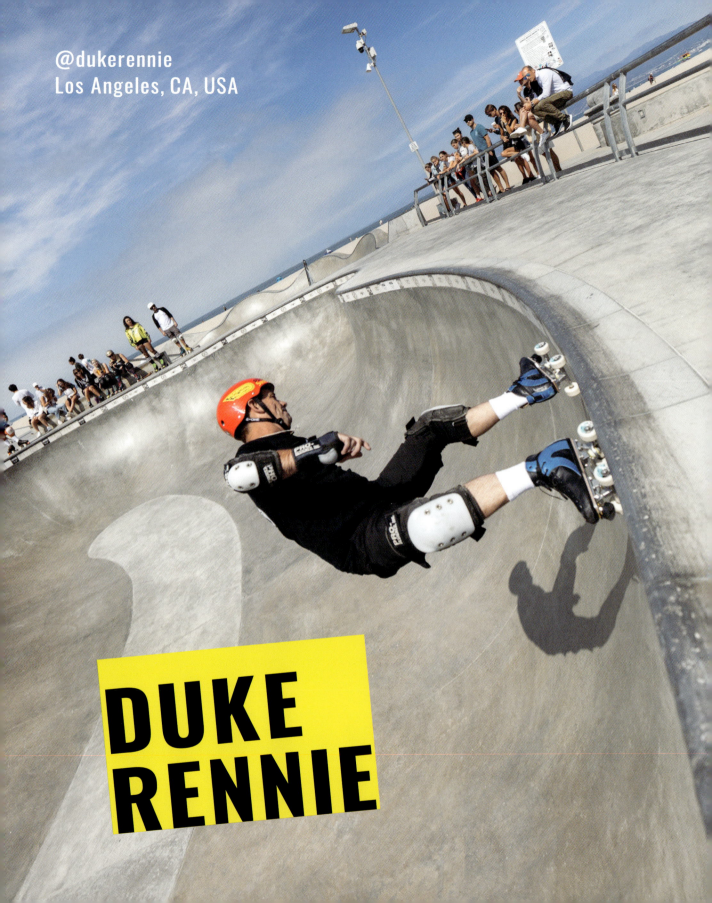

@dukerennie
Los Angeles, CA, USA

DUKE
RENNIE

Duke Rennie is one of the few veterans in aggressive or half-pipe roller skating who is still on skates at the age of 60. To this day, the Californian-born skater continues to venture down vertical ramps and bowls, astonishing even younger generations.

In 1976, at the young age of 14, his career literally took off. Teenagers like him from the greater Los Angeles area grew up surfing, skateboarding, and roller skating. At the time, roller sports were experiencing an all-time high, with hundreds, if not thousands, skating and dancing every day, especially at Venice Beach. And those who were somewhat more adventurous, like Duke Rennie, were pushing the limits of what was thought possible.

He skated every day after school with his friend, the equally legendary skater Fred Blood, and at some point, they stopped going to school at all, preferring to spend their days at skate parks instead. "There were constantly photo shoots for magazines and we were getting paid for it," he recalls. Sponsors were throwing money around, contests were springing up, and the teens were suddenly traveling the country as professional roller skaters.

"We thought we were going to do this roller skating rockstar thing forever," he says. But it didn't last. By the late 1970s, the surge of publicity had subsided, and roller skating and skateboarding were no longer mainstream, having returned to the underground. Duke Rennie looked for a job, got married, and later became a father. He remained a loyal half-pipe skater with occasional interruptions, breaking his ankle twice.

The seasoned veteran is happy to see so many roller skates back at the skate parks of California and elsewhere. He loves skating through Vans Skatepark in Huntington Beach, with its famous Combi Bowl over twelve feet deep and its two interconnected pools. "The way the bowl works for me is a never-ending list of possibilities, only limited by my imagination."

Duke Rennie zählt zu den wenigen Veteranen im Aggressive- beziehungsweise Halfpipe-Roller-Skating, der mit seinen 60 Jahren noch auf Rollschuhen steht. Bis heute wagt der Kalifornier sich vertikale Rampen und Bowls hinunter und sorgt auch bei jungen Menschen für Staunen.

1976, da war er gerade einmal 14 Jahre alt, begann seine im wahrsten Sinne des Wortes steile Karriere. Jugendliche wie er aus dem Großraum von Los Angeles wuchsen mit Surfen, Skateboarden und Roller Skaten auf. Damals erlebten die Rollsportarten absolute Höhen, täglich rollten und tanzten vor allem am Strand von Venice Beach Hunderte, wenn nicht Tausende. Und jene, die etwas wagemutiger waren, wie Duke Rennie, verschoben die Grenzen von dem, was bislang möglich gewesen war.

Mit seinem Freund und gleichfalls legendären Skater Fred Blood skatete er jeden Tag nach der Schule, irgendwann gingen sie gar nicht mehr hin und waren tagein, tagaus in Skateparks unterwegs. „Es gab ständig Fotoshootings für Magazine und wir wurden dafür bezahlt", erinnert er sich. Sponsoren warfen mit Geld um sich, Contests sprossen aus dem Boden und die Teenager waren plötzlich professionelle Roller Skater und reisten durch die USA.

„Wir dachten, dieses Roller-Skater-Rockstar-Leben würde immer so weitergehen", sagt er. Doch Ende der 70er Jahre ebbte die Publicitywelle ab, Roller Skaten und Skateboarden waren nicht mehr Mainstream. Duke Rennie suchte sich einen Job, heiratete, wurde später Vater. Dem Halfpipe-Skaten blieb er mit Unterbrechungen treu, zweimal brach er sich den Knöchel.

Den Veteranen macht es glücklich, dass man in Skateparks in Kalifornien und anderswo wieder so viele Rollschuhe sieht. Er selbst rollt am liebsten durch den Vans Skatepark in Huntington Beach. Dessen berühmte Combi Bowl ist über dreieinhalb Meter tief und besteht aus zwei miteinander verbundenen Pools. „Für mich bietet die Bowl unendlich viele Möglichkeiten, Grenzen setzt mir höchstens meine Vorstellungskraft."

Monsters of Roll 2004, Roller Skate Contest
in Woodward, CA, USA.

Duke performing an Invert at the legendary
Skatepark of Venice Beach, CA, USA.

Duke meistert einen Invert im legendären
Skatepark von Venice Beach, Kalifornien, USA.

Anke Dregnat never gave much thought to what you can do on roller skates. But during time spent abroad in Orléans, France, ten years ago, she heard about roller derby for the first time, and she was hooked. When she moved to Hamburg the following year, she joined the team based in the Hanseatic city.

She wasn't loyal to the sport for long, however, because videos of women on roller skates taking over the streets and skate parks were spreading across YouTube. The skaters were jumping down stairs or doing handstands on steep ramps. "That immediately grabbed me. All I could think was, I want to do that too!"

No sooner said than done. She and a friend went to the *I-Punkt* indoor skate park in Hamburg, embarking on an adventure. Anke met other women who shared her new passion. Unlike today, there weren't many female roller skaters in German skate parks back then. "In the beginning it was hard to learn the first tricks. I kept playing videos from the internet in slow motion, watching exactly what they were doing with their feet, because there wasn't anyone who could teach me how to do it here," she recalls.

But Anke had always been athletic. Without being afraid of falling and with a good bit of perseverance, she learned jump after jump, grind after grind. Anyone who has ever watched her whiz through bowls more than six feet deep and master 360-degree jumps with ease will inevitably become entranced. "I'm in my element here," she says.

The feeling she has on roller skates, the passion, the urge to throw herself into it is something she had never felt before. When the sun is shining and Anke is not at the indoor skate park, you will probably find her dancing around the roller skating rink in the *Planten un Blomen* park. Jam skating is her second love, and offers a nice distraction from the adrenaline rush.

Was man so alles auf Rollschuhen machen kann, darüber hat Anke Dregnat früher nie nachgedacht. Doch während eines Auslandsaufenthalts vor zehn Jahren im französischen Orléans hörte sie zum ersten Mal von Roller Derby und war begeistert. Als sie im Jahr darauf nach Hamburg zog, trat sie dem Team der Hansestadt bei.

Treu blieb sie dem Sport nicht lange, denn auf YouTube verbreiteten sich zunehmend Videos von Frauen auf Roller Skates, die die Straßen und Skateparks eroberten. Sie sprangen Treppen hinunter oder machten Handstände in steilen Rampen. „Das hat mich sofort gecatcht. Ich dachte nur: Das will ich auch machen!"

Gesagt, getan. Mit einer Freundin fuhr sie in die Hamburger I-Punkt Skatehalle. Und sie stürzten sich ins Abenteuer. Anke lernte weitere Hamburgerinnen kennen, die ihre neue Leidenschaft teilten. Im Gegensatz zu heute waren in Deutschland damals noch nicht viele Roller Skaterinnen in Skateparks unterwegs. „Anfangs war es hart, sich die ersten Tricks zu erarbeiten. Ich habe Videos aus dem Netz immer wieder in Zeitlupe abgespielt, mir genau angeguckt, was die mit ihren Füßen machen, denn es gab einfach niemanden, von dem man das hier lernen konnte", erinnert sie sich.

Doch Anke war schon immer sportlich. Ohne Angst vor dem Fallen, dafür mit einer ordentlichen Prise Hartnäckigkeit, lernte sie Sprung um Sprung, Grind um Grind. Wer die Wahlhamburgerin beobachtet, wie sie durch zwei Meter tiefe Bowls flitzt und 360°-Sprünge um die eigene Achse mit Leichtigkeit meistert, kommt unweigerlich ins Schwärmen. „Hier bin ich in meinem Element", sagt sie.

Das Gefühl, das sie auf Rollschuhen habe, also diese Leidenschaft und den Drang, sich reinzuhängen, das habe sie noch nie so gespürt. Wenn Anke gerade nicht in der Halle anzutreffen ist, aber die Sonne scheint, tanzt sie vermutlich über die Rollschuhbahn im Park Planten un Blomen. Denn Jam Skating ist ihre zweite Passion und eine schöne Abwechslung zum Adrenalinkick.

ANKE DREGNAT

@splatterling.anke
Hamburg, Germany

As a versatile skater, Anke masters a wide variety of tricks (clockwise): from the Cartwheel to the Makio Grind to the Judo Air to the Monkey Flip.

Anke beherrscht als vielseitige Skaterin verschiedenste Tricks (im Uhrzeigersinn): vom Rad über den Makio Grind und Judo Air bis zum Monkey Flip.

ROLLER

DERBY

@ahsinity
Austin, TX, USA

TINISHA BONABY

Tinisha Bonaby has been skating since she could walk. When she was two, her father, an avid rhythm skater, strapped her into roller skates for the first time. Roller skating is a tradition in the family from Houston, Texas.

It was her father who handed the now 32-year-old a flyer from the local roller derby team back in 2011. "He got it from the owner of a skate shop. He had asked him if he had a daughter," she recalls. And because roller derby is played on roller skates, she quickly took a liking to it. "There's an element of speed, agility, strength, and tenacity that's important for this game and I enjoy that."

In 2015, following her father's advice, she moved to Austin to join the Texas Rollergirls. "At some point I wanted a greater challenge." And she found it with the creators of modern flat track roller derby, Texas Rollergirls. The team was ranked number three in the world at the time.

Tinisha, who plays under the derby name of Freight Train, brought her agility from two decades as a jam skater, but her opponents fear her because of her strength. When she can't dance past defensive players, she blocks them. Despite the fast-paced action, she radiates an inner calmness that no one seems to be able to disrupt. She stands calmly at the starting line with a stoically concentrated expression on her face that remains even after the whistle blows.

But there's also the Tinisha who beams and laughs as she roller skates or teaches beginner classes, skate fitness, and roller dancing in Austin under Sk8wTinisha Skate Lessons (@sk8wtinisha). In demand as a roller derby coach, she has traveled to Alaska, Canada, Australia, New Zealand, Iceland, the Netherlands, and England. But her favorite thing to do is to go to Las Vegas for the annual RollerCon, a cross between a convention, a networking meetup and an all-around roller derby event for thousands of enthusiasts who dance the night away in crazy outfits after sweaty workouts and games.

Tinisha Bonaby kann skaten, seit sie laufen kann. Als sie zwei Jahre alt war, schnallte ihr Vater, ein leidenschaftlicher Rhythm Skater, ihr das erste Mal Rollschuhe an. Roller Skating hat Tradition in der Familie aus dem texanischen Houston.

Ihr Vater war es auch, der der heute 32-Jährigen 2011 einen Flyer des lokalen Roller-Derby-Teams in die Hand drückte. „Er erhielt ihn von einem Skateshop-Betreiber. Der hatte ihn gefragt, ob er eine Tochter habe", erinnert sie sich. Und weil man Roller Derby auf Rollschuhen spielt, fand sie schnell Gefallen daran. „Bei diesem Spiel kommt es auf Geschwindigkeit, Beweglichkeit, Kraft und Ausdauer an, und das macht mir Spaß."

2015 wechselte sie auf den Rat ihres Vaters nach Austin zu den Texas Rollergirls. „Irgendwann wollte ich eine noch größere Herausforderung." Die fand sie bei den Begründerinnen des modernen Flat Track Roller Derby. Das Team war damals die Nummer drei der Welt.

Die Agilität brachte Tinisha, die unter dem Alias Freight Train spielt, aus zwei Dekaden als Tänzerin mit. Gegnerinnen fürchten sie aber auch für ihre Kraft. Wenn sie nicht an den Defensivspielerinnen vorbeitänzeln kann, blockt sie sie aus dem Weg. Dabei strahlt sie trotz des hohen Spieltempos eine innere Ruhe aus, die scheinbar niemand erschüttern kann. An der Startlinie steht sie ruhig mit einem stoisch-konzentrierten Gesichtsausduck da, der auch nach dem Anpfiff nicht verschwindet.

Doch es gibt auch die Tinisha, die strahlt und lacht, wenn sie auf Rollschuhen tanzt oder in Austin Anfängerkurse, Skate-Fitness und Roller Dancing unterrichtet (@sk8wtinisha). Als gefragte Roller-Derby-Trainerin reiste sie bereits nach Alaska, Kanada, Australien, Neuseeland, Island,die Niederlande und England. Am liebsten fährt sie jedoch zur alljährlich RollerCon nach Las Vegas, ein Mix aus Tagung, Netzwerktreffen und Rundum-Roller-Derby-Event für tausende Enthusiastinnen, die nach schweißtreibenden Trainings und Spielen die Nächte in verrückten Outfits durchtanzen.

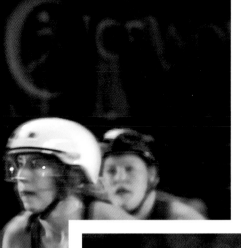

Left page/linke Seite: 2017 WFTDA Champs, Philadelphia, PA, USA. Texas Roller Derby vs. Minnesota Roller Derby.

This page/diese Seite: Rollercon 2022, Las Vegas, NV, USA. Riedell vs. S1.

ROLLER DERBY

LOREN
KAPLAN MUTCH

One of Loren Kaplan Mutch's fondest memories is her first win at the International WFTDA Championships in 2015. She was just 22 years old and her team, Rose City Rollers, defeated New York's Gotham Roller Derby, which had been undefeated since 2011. "It was a hard-fought match, and I still remember how insanely loud it was in the arena," she recalls.

In roller derby, the association's championship is much like the Champions League in soccer. Loren, known to many under the skater name Mutch Mayhem, began her career at the age of 14 in Port Orchard, Washington. "I fell in love with roller derby at my first tournament, when I was surrounded by a community of people who shared this love."

In 2011, she moved to Portland, joining the Rose City team a year later. They are among the best in the world. "Roller derby requires structure and teamwork, and it has taught me how to tap into my flow state to compete and perform well under pressure." For Loren, no other feeling compares to the energy and adrenaline on game day.

After fighting hard throughout the season, she feels a deep connection to her teammates. This community is important to her in other ways, too. It's where she felt safe enough to come out. "I'm also proud to be a part of a sport that is inclusive for all gender-expansive individuals."

Loren is truly an exceptional athlete in roller derby, something which hasn't gone unnoticed. For six years, Red Bull sponsored her, something afforded few in a sport outside the mainstream. "I was able to make a modest living off of skating. Red Bull has amazing trainers and physiotherapists that helped me train my best and move forward in my career."

Roller derby is a lifestyle for her. No matter how tough the challenge, it never feels like a sacrifice. "It's so rewarding in the end."

Eine der schönsten Erinnerungen von Loren Kaplan Mutch ist ihr erster Sieg bei den International WFTDA Championships 2015. Damals war sie gerade einmal 22 Jahre alt und mit ihrem Team Rose City Rollers bezwang sie die seit 2011 ungeschlagenen New Yorkerinnen von Gotham Roller Derby. „Es war ein hart umkämpftes Spiel, und ich erinnere mich noch daran, wie wahnsinnig laut es in der Arena war", sagt sie.

Im Roller Derby ist die Meisterschaft des Verbands so etwas wie die Champions League im Fußball. Loren, die vielen unter dem Alias Mutch Mayhem bekannt ist, begann ihre Karriere bereits im Alter von 14 Jahren in Port Orchard, Washington. „Ich verliebte mich bei meinem ersten Turnier in Roller Derby, denn ich fand mich umgeben von Menschen, die diese Liebe teilten."

Im Jahr 2011 zog sie nach Portland, um ein Jahr später im Team von Rose City zu spielen. Weltweit gehören sie zu den Besten. „Roller Derby erfordert Struktur und Teamarbeit. Es hat mich gelehrt, wie ich in einen Flow-Zustand komme, um unter Druck gute Leistungen zu bringen." Für Loren gibt es kein Gefühl, das sich mit der Energie und dem Adrenalin an einem Spieltag vergleichen lässt.

Wenn sie sich durch eine aufreibende Saison gekämpft hat, spürt sie eine tiefe Verbindung zu ihren Teamkameradinnen. Auch sonst ist diese Gemeinschaft wichtig für sie. Hier fühlte sie sich sicher genug für ihr Coming-out. „Ich bin stolz darauf, einem Sport anzugehören, der Gender-expansiven Menschen offensteht."

Loren ist wahrlich eine Ausnahmeathletin im Roller Derby. Das blieb nicht unbemerkt. Sechs Jahre lang wurde sie von Red Bull gesponsert, etwas, das nur wenigen in einem Sport abseits des Mainstreams zuteilwird. „Das ermöglichte mir, einen bescheidenen Lebensunterhalt mit dem Skaten zu verdienen. Red Bull hat großartige Trainer und Physiotherapeuten, die mir halfen, meine Karriere voranzutreiben."

Roller Derby ist für sie ein Lebensstil. Ganz gleich, wie groß die Herausforderung, nie fühle es sich wie Opfer bringen an. „Es lohnt sich am Ende."

Left page/linke Seite: 2017 WFTDA Champs, Philadelphia, PA, USA. Rose City Rollers vs. Arch Rival Roller Derby.

Top/oben: Rollercon 2022, Las Vegas, NV, USA. Riedell vs. S1.

Bottom/unten: 2017 WFTDA Champs, Philadelphia, PA, USA. Rose City Rollers vs. Gotham Roller Derby.

ROLLER DERBY

NELE VAN BOGAERT

Sometimes, at the height of the season, Nele van Bogaert, aka Party Pants, formerly Humpme, dreams about new game strategies for roller derby. Though the fact that she thinks about it day and night does bring a smile to her face, Nele also admits she is downright obsessed with roller derby.

When the Belgian athlete started her derby career in Antwerp some ten years ago, she put the sport before everything else, quickly maturing into a top player, coach, Belgian national player, and sought-after game strategist. "I loved Antwerp Roller Derby. I've rarely seen such a dedicated team," she says.

But her ambition proved to be greater. In early 2018, she applied to join London Roller Derby, one of the world's best teams. They were unrivaled on the track in Europe. Nele made it onto London Brawling A team and competed in her first big matches.

But then suddenly the pandemic hit, and skating was gone. "I felt extremely lonely. I had moved to London to skate. Without roller derby, I didn't want to live there." She didn't have any friends outside of the sport, so she began skating through her neighborhood during the first lockdown. "I discovered there were actually different types of skate crews in London." For instance, jam skaters who found refuge in a nearby parking garage. Nele gave jam skating and the skate park a try, soaking up the energy, making new friends. And she continued to skate through the streets on her own.

"Out of the blue, people were constantly asking me if I would teach them." And did she ever. Today, Nele continues to compete in roller derby in London, while also running her own roller skating school. "At Isle of Skating, I employ a staff of 20 to teach 450 skaters every week at 14 locations." The roller skate hype of the pandemic has not abated in London. "After two years of very hard work, I am now at a point where I am running an established business." Skating is now her life, in the truest sense of the word.

Manchmal, wenn Hochsaison ist, träumt Nele van Bogaert alias Party Pants, ehem. Humpme, von neuen Spielstrategien für Roller Derby. Es bringt sie zum Schmunzeln, dass sie Tag und Nacht darüber nachdenkt, doch Nele sagt auch, sie sei geradezu besessen von Roller Derby.

Als die Belgierin vor rund zwölf Jahren in Antwerpen ihre Derby-Karriere startete, ordnete sie dem Sport alles unter, mauserte sich schnell zur Topspielerin, Trainerin, belgischen Nationalspielerin und gefragter Spielstrategin. „Ich liebte Antwerpen Roller Derby, ich habe selten ein derart engagiertes Team erlebt", sagt sie.

Doch ihr Ehrgeiz war größer. Anfang 2018 bewarb sie sich für das Team von London Roller Derby, eines der besten Teams der Welt. In Europa konnte ihnen auf dem Track niemand das Wasser reichen. Nele schaffte es in die A-Mannschaft London Brawling und absolvierte ihre ersten großen Spiele.

Doch plötzlich war die Pandemie da und das Skaten weg. „Ich fühlte mich extrem einsam. Ich war nach London gezogen, um zu Skaten. Ohne Derby dort leben wollte ich nicht." Freunde außerhalb des Sports hatte sie nicht, und so begann sie während des ersten Lockdowns durch ihr Viertel zu skaten. „Ich entdeckte, dass es in London tatsächlich verschiedene Arten von Skate-Crews gab." Etwa Tänzer, die in einem nahegelegenen Parkhaus Zuflucht fanden. Nele versuchte sich im Tanzen und im Skatepark, sog die Energie auf, schloss neue Freundschaften. Und sie rollte weiter allein über die Straßen.

„Plötzlich fragten mich ständig Leute, ob ich sie unterrichten würde." Und ob sie wollte. Heute spielt sie weiter Roller Derby in London und leitet zusätzlich ihre eigene Skateschule. „Bei Isle of Skating beschäftige ich 20 Menschen, die in 14 Locations jede Woche 450 Skater unterrichten." Der Roller-Skate-Hype der Pandemie ist in London nicht abgeebbt. „Nach zwei Jahren sehr harter Arbeit bin ich jetzt an einem Punkt, an dem ich ein etabliertes Unternehmen führe." Skaten, das ist im wahrsten Sinne des Wortes nun ihr Leben.

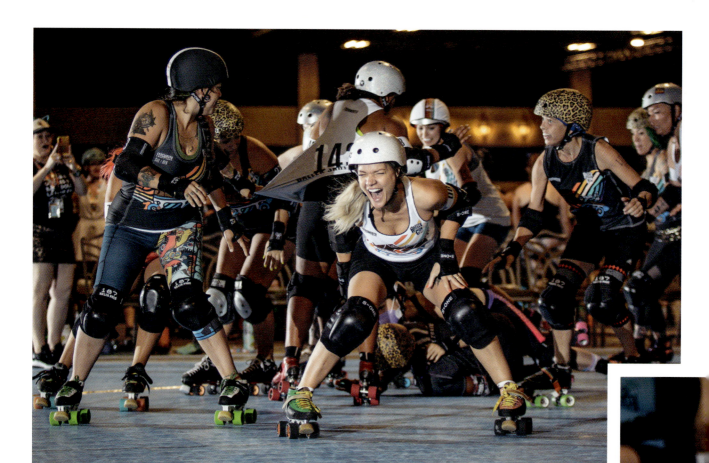

This page/diese Seite: 2022 Rollercon,
Las Vegas, NV, USA. "Decade of Derby".

Right page/rechte Seite: 2022 Rollercon,
Las Vegas, NV, USA, Frogmouth vs. Chaya.

THE AUTHOR | DIE AUTORIN

Marta Popowska is a freelance journalist and author. She earned a degree in English and history, as well as graduating from journalism school. Marta is a passionate roller skater and former roller derby player. When she is not on wheels, she writes for newspapers and magazines, and is the editor of *DogDays Magazine*, an established international roller skating magazine.

Marta Popowska ist freie Journalistin und Autorin. Sie hat Anglistik und Geschichte studiert, ist Absolventin der Reportageschule in Reutlingen und fährt leidenschaftlich gerne Rollschuh. Ist die ehemalige Roller-Derby-Spielerin gerade nicht in Bewegung, schreibt sie für Zeitungen und Magazine und ist Herausgeberin von *DogDays Magazine*, einem etablierten internationalen Roller-Skate-Magazin.

IMPRINT | IMPRESSUM

© 2023 teNeues Verlag GmbH

1st printing

Texts by Marta Popowska. All rights reserved.
Idea, Editorial Coordination, Picture Research,
Copyediting by Birthe Vogelmann
Translation by Robin Limmeroth
Design by Eva Stadler
Production by Alwine Krebber, teNeues Verlag
Picture Editing, Color Separation by Robert Kuhlendahl,
teNeues Verlag

Library of Congress Number: 2023934492
ISBN: 978-3-96171-445-2

Printed by GPS in BiH

Bibliographic information published by the
Deutsche Nationalbibliothek:
The Deutsche Nationalbibliothek lists this publication in
the Deutsche Nationalbibliografie; detailed bibliographic
data are available on the Internet at dnb.dnb.de.

Published by teNeues Publishing Group

teNeues Verlag GmbH
Ohmstraße 8a
86199 Augsburg, Germany

Düsseldorf Office
Waldenburger Straße 13
41564 Kaarst, Germany
e-mail: books@teneues.com

Augsburg/Munich Office
Ohmstraße 8a
86199 Augsburg, Germany
e-mail: books@teneues.com

Berlin Office
Lietzenburger Straße 53
10719 Berlin, Germany
e-mail: books@teneues.com

Press Department
presse@teneues.com

teNeues Publishing Company
350 Seventh Avenue, Suite 301
New York, NY 10001, USA
Phone: +1-212-627-9090
Fax: +1-212-627-9511

www.teneues.com